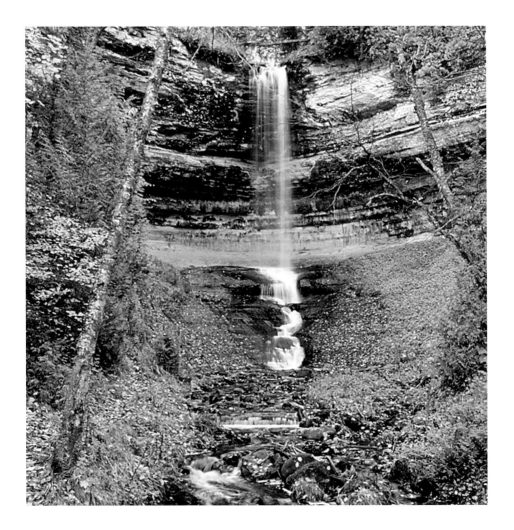

Pictured Rocks

National Lakeshore

photography by Terry W. Phipps

The University of Michigan Press
and
Petoskey Publishing

For
Martin and Cheryl Trepus

Copyright © Terry W. Phipps 2008
Margaret Rose Kelly, editor

Published in the United States of America by
The University of Michigan Press
and
The Petoskey Publishing Company

Manufactured in Canada
20011 20010 2009 2008 5 4 3 2 1
ISBN-10: 0-472-11677-0
ISBN-13: 978-0-472-11677-5
Library of Congress Cataloging-in-Publication Data on File

Signed Limited Edition Prints
t.phipps@greatlakestraveler.com

Other titles include:
*Seasons of Mackinac, Seasons of Sleeping Bear, Seasons of Little Traverse
Mackinac Island,* and *Sleeping Bear Dunes National Lakeshore*

Foreword

Pictured Rocks National Lakeshore was the result of a vision born out of the 1958 Great Lakes Shoreline Study. The vision recognized that ever so slowly, places like Michigan's Upper Peninsula would eventually be owned by only a few individuals, and our nation's citizenry would not have access to the incredible scenic beauty of places like the Pictured Rocks, Twelve Mile Beach, and Grand Sable Dunes. The vision became a reality in 1966 when Congress declared this the first national lakeshore. Forty years of preservation and management by the National Park Service and enjoyed by millions of visitors, the lakeshore has become perhaps even more important than its founders could have imagined.

As open space continues to disappear rapidly and our lives become more hectic every day, this park that stretches over forty miles along the south shore of Lake Superior is a haven for those seeking relaxation, challenge reflection, inspiration, indeed the elemental roots of our existence.

Like a favorite quilt passed down from grandma, Pictured Rocks National Lakeshore is a mosaic of our northwoods natural and cultural heritage. From the Grand Sable Dunes near Grand Marais to the famous Pictured Rocks cliffs northeast of Munising, the varied landscape is home of the black bear, timber wolves, American Marten, and an occasional moose. Inland lakes and trout brooks drain a relatively short watershed to Lake Superior, one of earths' greatest lakes. Rare orchids, ferns, and thistle thrive in secluded isolation. Low-growing plants that normally live in the arctic cling to the windswept cliffs. It is a landscape that has been wrought too by humankind. Archeological evidence and oral tradition tell us that people have lived here for over 4,000 years. Anishnabe, French-Canadian fur traders, and lumberjacks moved through the area with a range of impacts on the land. U.S. Life Saving Service and Coast Guard lifeboat crews, along with lone lighthouse keepers, scanned the stormy horizon for travelers in distress.

All of these stories are played out on a palette of seemingly undisturbed ecological processes. Here, nature is taking her course of erosion, transformation, adaptation, energy cycling, and evolution.

The images captured by Terry Phipps on the following pages have captured the essence of this special place. I hope they will encourage you to visit the lakeshore and discover your own experiences, mental images, unique fragrances, and memories. Pictured Rocks National Lakeshore—wild beauty on the Lake Superior shore.

Greg L. Bruff
Chief of Heritage Education, Pictured Rocks National Lakeshore

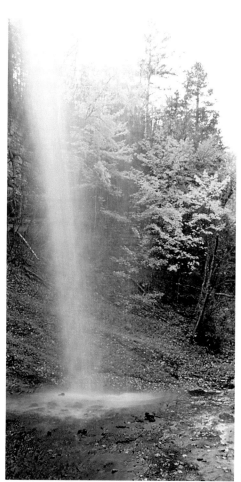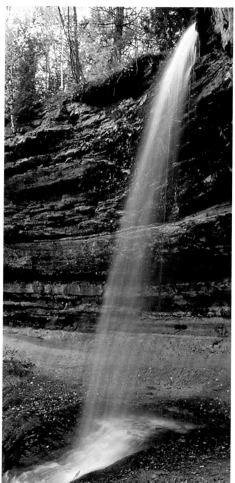

Munising Falls

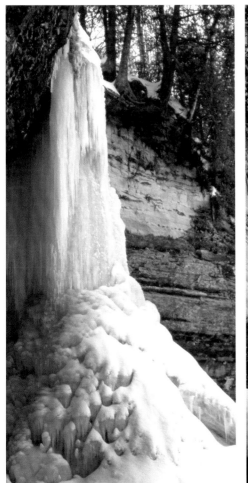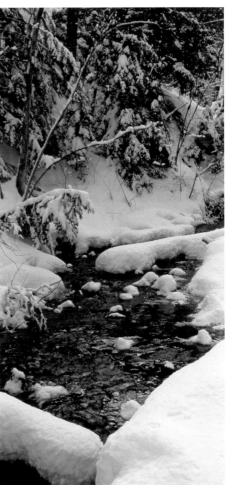

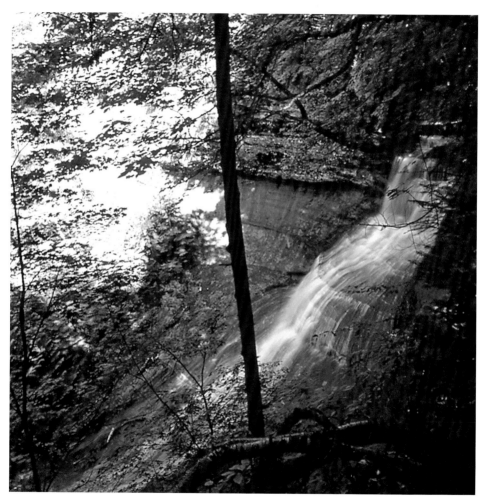

Chapel Falls

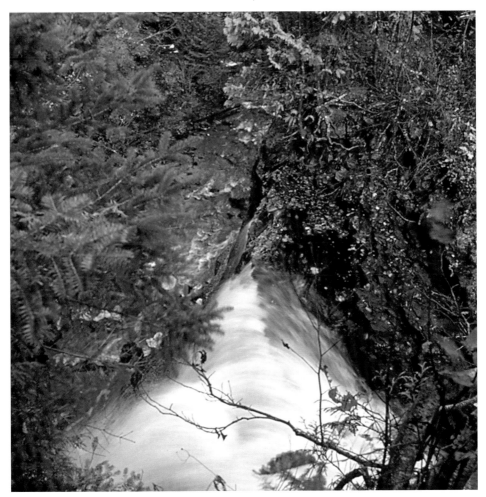

Miners Falls

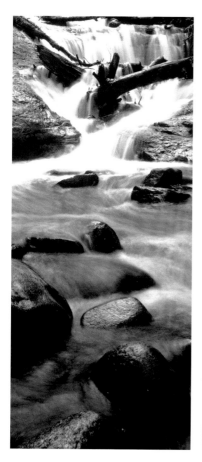
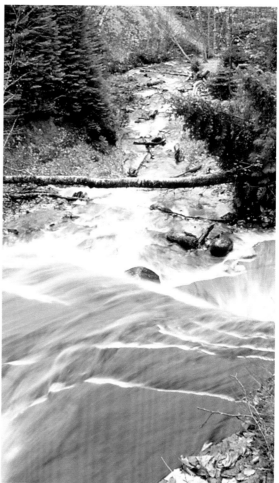

Sable Falls

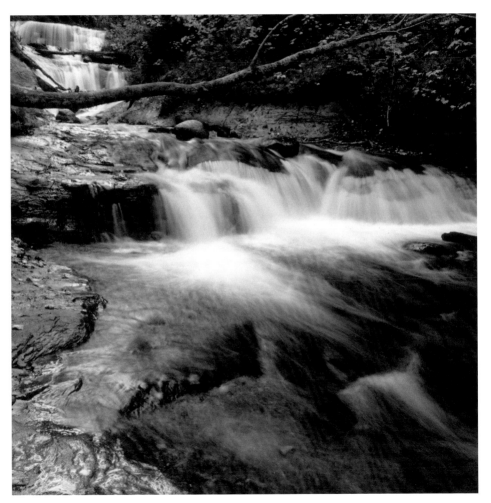

Spray Falls

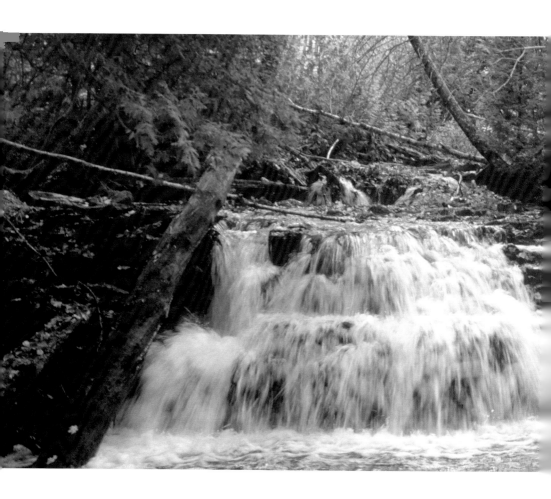

Mosquito Falls

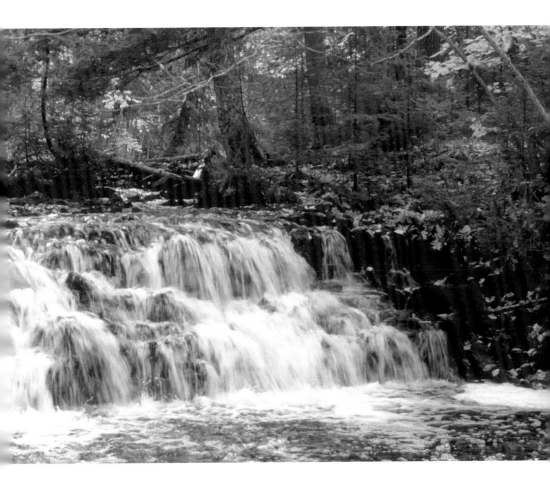

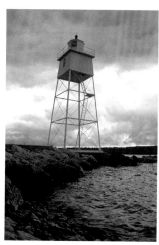
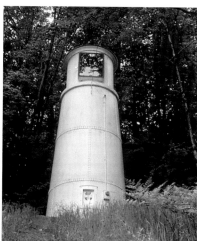
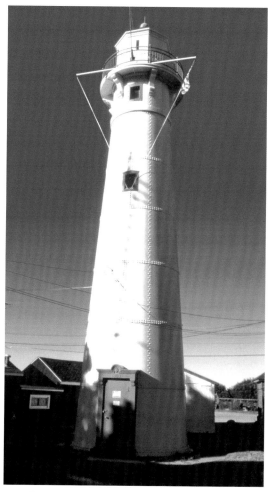

Grand Marais Rear Range Light and Munising Range Lights

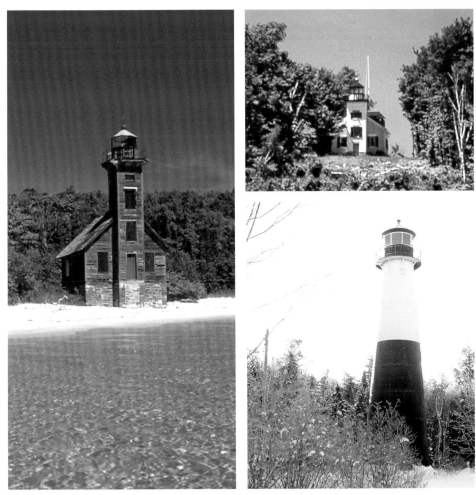

Grand Island E. Channel, North Light, and W. Channel Range Light

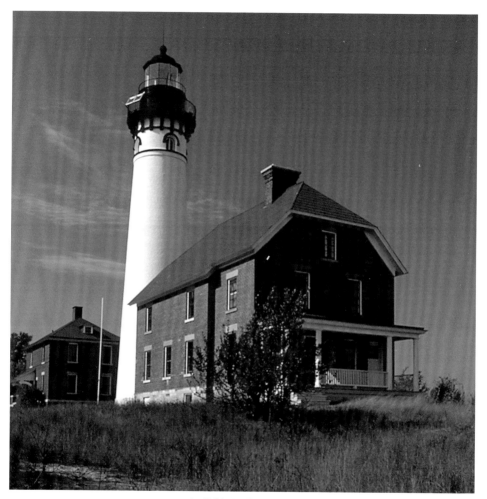

Au Sable Light Station

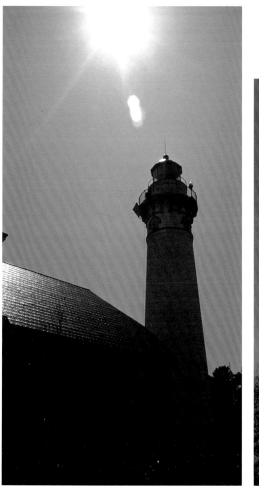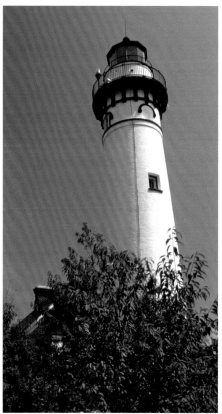

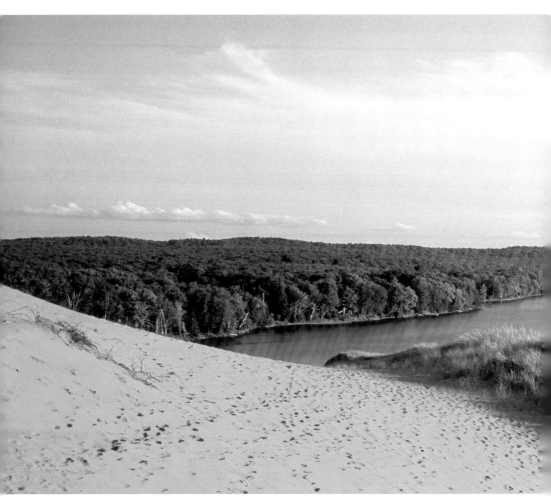

Grand Sable Dunes and Grand Sable Lake

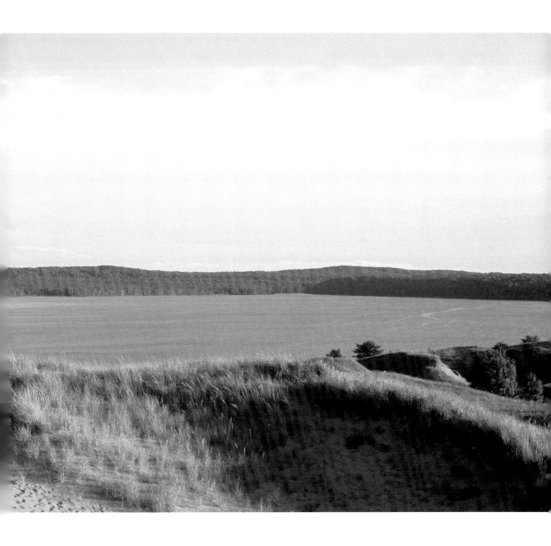

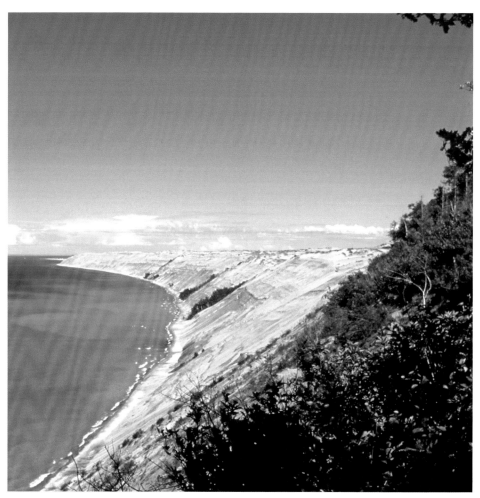

Grand Sable Banks

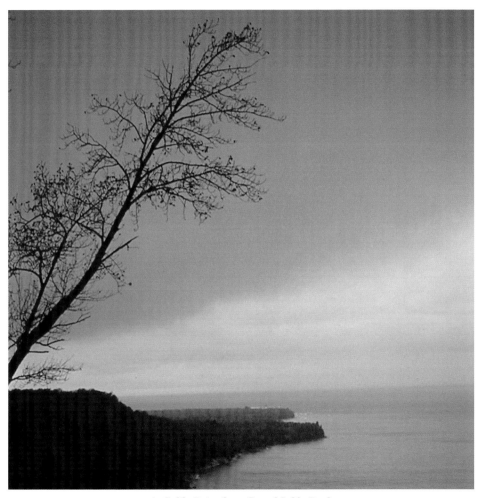

Au Sable Point from Grand Sable Banks

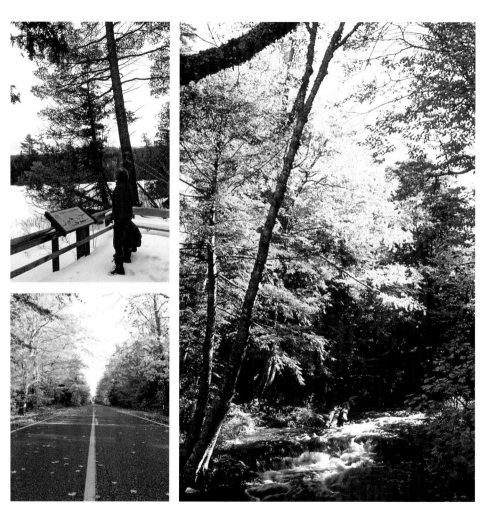

Hurricane River, Sand Point Marshland Trail, and road to Miners Castle

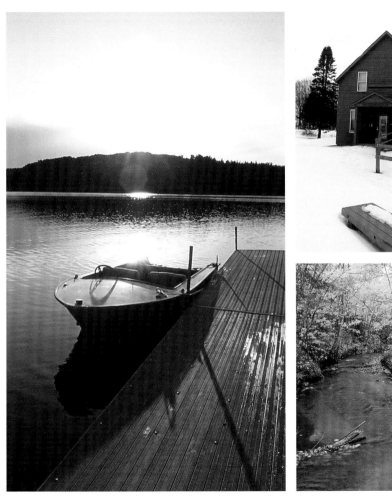

Great Lake at the boat dock, Grand Sable Visitor Center, and Sable Creek

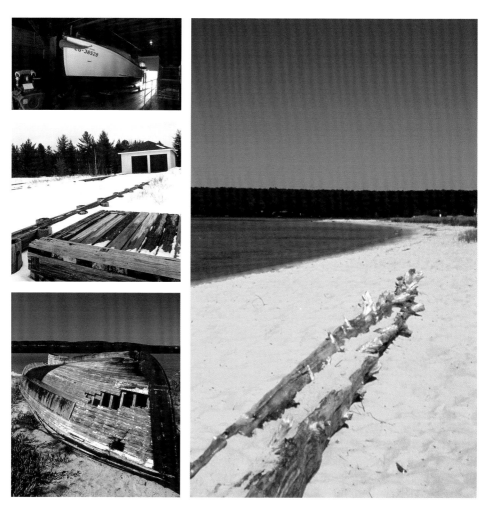

Sand Point Maritime Exhibits

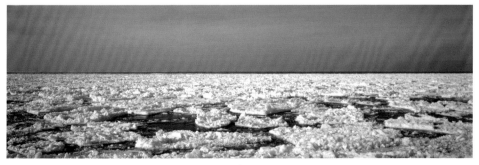

Sand Point

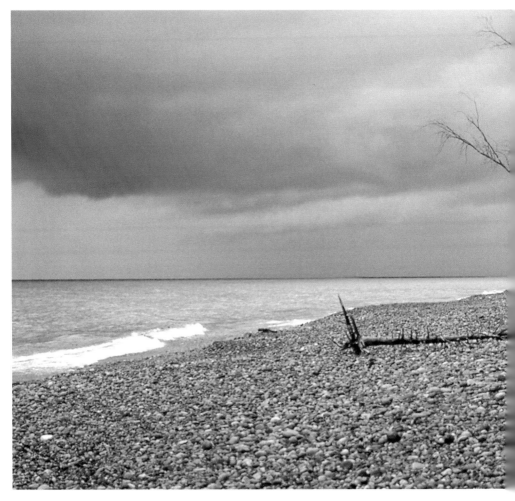

Agate beaches along the shoreline

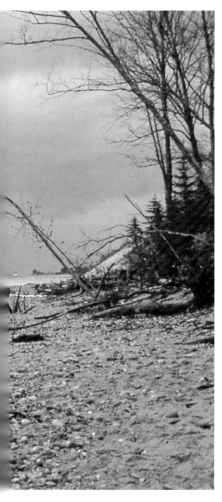

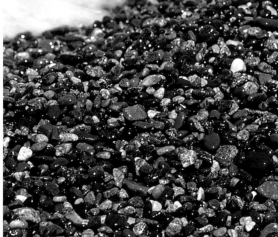

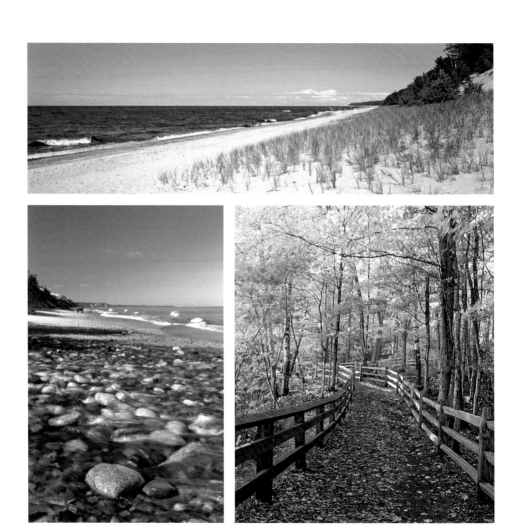

Twelvemile Beach, Sable Creek, and Miners Castle Trail

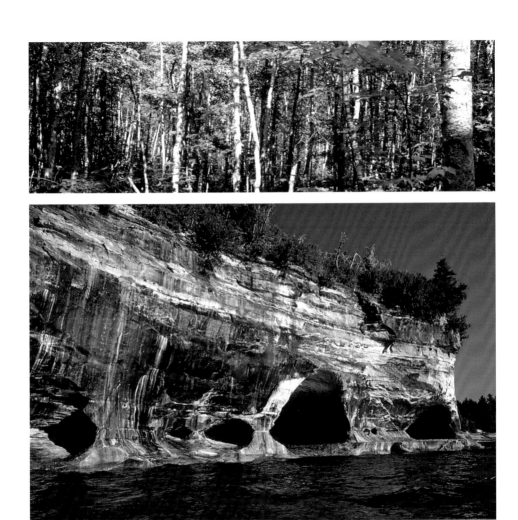

The Birch Forest near Twelvemile Beach and Caves of the Bloody Chiefs

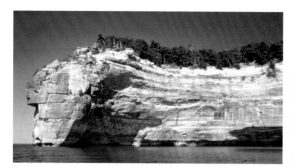

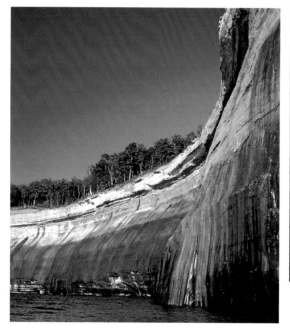

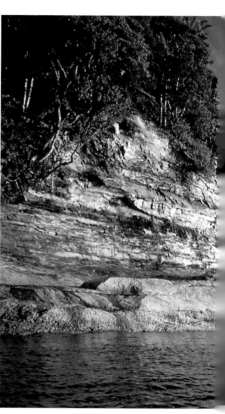

Indianhead, Painted Cliffs, and Chapel Rock

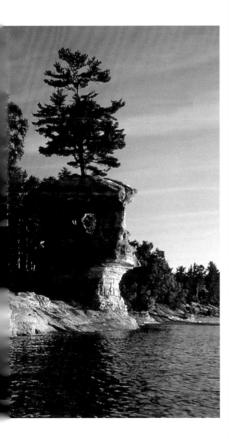
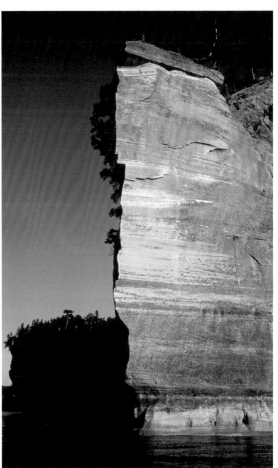

Battleship Row

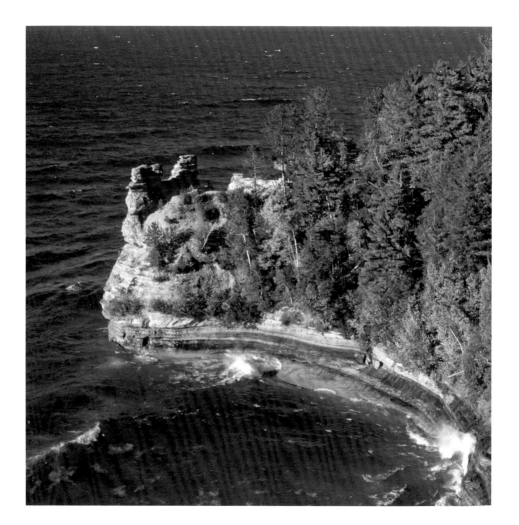